Sage Words

A Book of Poems by
Jet Widick

Handlettering and Illustration by
Kimberly 國子 Taylor-Pestell

This passion project is dedicated to:

MHW is an ear surgeon and photographer,
and the one who "discovered" me at 16-years-old.

The Boyz, my sons Douglas and John.

And many other epic magnets I give a huge thank you for having inspired
me and shown me unconditional love and incredible kindness.

Introduction and poetry copyright © 2016 by JET WIDICK.
Illustration and hand lettering copyright © 2016 by KIMBERLY K. TAYLOR-PESTELL.

ISBN 9781088193235. Hardcover, second edition printing: June 2023.

Creative direction and design by Kristen Alden.

NorthCoast Post, LLC
420 N. Third Street
Marquette, MI 49855

www.northcoastpostmedia.com

☆ THREE'S A CHARM ☆

In October, 2015, I received a phone call from Jet about a web design and branding project. Her sister is a local client and passed along my name when she found out Jet was looking for a graphic designer. I live in the upper peninsula of Michigan. Jet lives in Boca Raton, Florida.

About 2 months into working together, she sends a book to me in the mail. It's Lisa Congdon's *Whatever You Are, Be A Good One*. Jet tells me she would like to publish a book of her poetry; a beautiful and meaningful book like Lisa's suitable for gift-giving. I immediately thought of my friend Kimberly in Southern California as the perfect artist for the job. She is also a fan of Lisa Congdon and introduced her artwork to me when Kimberly and I worked together out west.

As a graphic designer, I'm constantly deconstructing meaning and messaging from the symbols, shapes and colors surrounding us. I love that the collaborative process behind *Sage Words* involved 3 people—a triad—and if you were to connect the points on a map between each of our respective cities, it would create a colossal triangle.

The power of three is universal. Any structure requiring strong and stable construction depends on triangles to achieve that goal, and designers, artists and musicians use the rule of thirds to create harmony in their compositions. Human development occurs in three main stages, and 3 represents the triads of body, soul and spirit. Beginning, middle and end. Desire, action and results.

Even though the three of us live in different and distant cities, we now have a commonality between us, linked together by our complementary strengths. Three is symmetry, three is beauty, three is magic.

INTRODUCTION

Poems have been swirling around in my mind for as long as I can remember, especially with rhythm or cadence.

When I was young I would make cards for friends and family, and then—when I had children and was "room mom" for their classes at school—I wrote poems about the year's events for the students to rap and recite to the teachers as holiday or end-of-year gifts. It was so entertaining and delightful to hear those first grade emcees run the show!

But as the kids got older, day-to-day life responsibilies took over and I found little time for creativity. Then one day, the sun beamed in and things became lighter… and brighter. A perspective shift occured. A metamorphosis. Caterpillar to butterfly, and things fly!

I began making up toasts at parties and family gatherings, and the poems came back. They returned to me as I lay down at night to fall asleep—inspired by the beautiful people in my life: my husband's surgeon hands restoring peoples hearing, memories of my children as little boys, the feelings of old and wise relatives, friends passing away or the blind man who crosses the six-lane highway each day on his way to work.

I realized what I had built and that life's accomplishments are something to outwardly express gratitude toward. Let's let people know how much we love them. Let's tell them how much we appreciate all they do and have done for us in every way we can... because life is a precious gift.

Everything I want to say the most
I jot down in a poem, or in a toast
I won't forget what I want to say
When we get to have a day to play
They come to me as I fall asleep
Into me they sweep
I feel it deep
The benefits I reap
To tell you what you mean to me
That you can see
The best things in life are free

Your Home

Your home feels WARM like a blanket
a fleece jacket, no need to check
your back pocket, because you found it,
like an overstuffed chair HOLDS YOU
right there

It's REAL
Splendid as a homemade meal,
makes you FEEL your body can HEAL
stops the wheel, quits the reel

It's IDEAL
Like a SOFT bed,
a pat to your head,
fresh baked BREAD

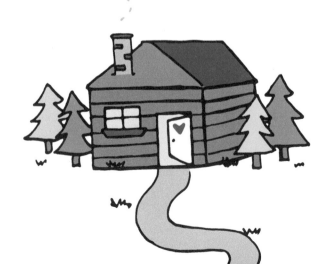

A flannel throw, fireplace GLOW,
It's the things you KNOW

Its warmth PREVAILS,
with cold cocktails

Hot coffee brewing
STOPS YOU from what you're doing

It's wool socks, CLASSIC rock

A sweetness like a baby's kiss,
BLISS exists, tranquility persists

Home it is.

ONE FOR EACH HAND
WELCOME TO MY WONDERLAND
THE WORLD OF SONS
AND EVERLASTING FUN
BOOKS AND GUITARS, GAMES AND DARTH VADERS
DINOSAURS AND CREATORS
OF SONGS THAT ROCKED AND STORIES
THAT MADE YOUR KNEES KNOCK
SWIMMING AND BOAT DOCKS
WISH I COULD TURN BACK THE CLOCKS
MAKE TIME UNLOCK

SO I CAN WATCH
YOU RIDE YOUR BIG WHEEL
ONE MORE TIME
AROUND THE BLOCK

Boyz

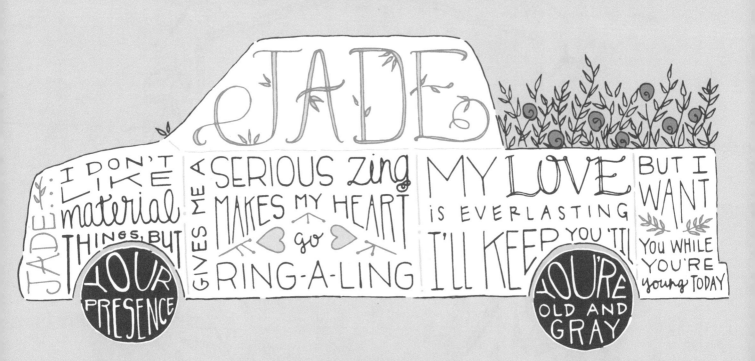

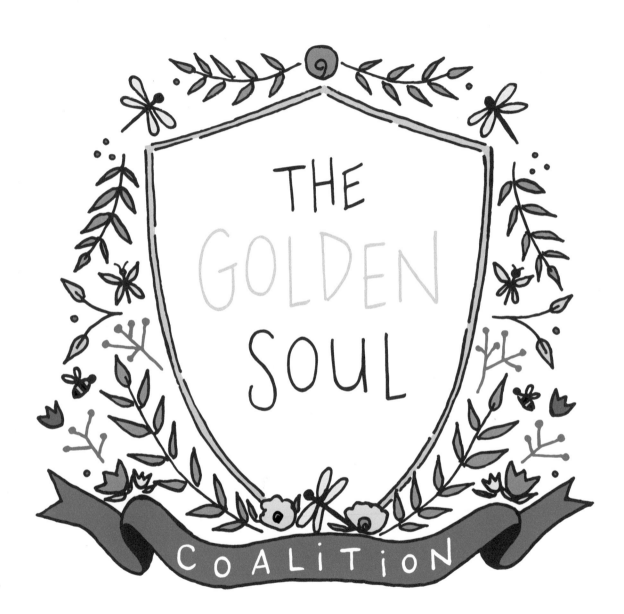

THE GOLDEN SOUL

COALITION

THIS SOUL COALITION
IS A STRONG LOVE ❦ SOMETHING
NOT MANY HAVE HEARD OF ◦ AS
THIS STORY UNFOLDS ❦ WE'RE NOT
YOUNG AND WE'RE NOT OLD ◦ IT'S DEEP
FRIENDSHIP ◦ SHARING LIFE'S TIPS ❦ DOESN'T
HAPPEN OFTEN ❦ ONLY TO ORPHANS ◦ SOME MIGHT
NOT GET IT, BUT IT'S A REAL HIT ❦ IT'S THE TRUEST
SURVIVAL THAT NOTHING CAN RIVAL ◦ IT'S THE HIGHEST
HIGH AND SUNNY ◦ IT'S FUN AND FUNNY ❦ NOTHING MESSED
UP ❦ JUST ORPHAN KINSHIP ◦ IT'S PUSHED-BACK EASY
CHAIRS AND TUFTS OF GRAY HAIRS ❦ IT'S BRIGHT INSIGHT
MAKES LIFE RIGHT ❦ JUST HAPPY TO BE ◦ VIBRANT AND
HEALTHY ◦ JOIN THIS RADIANT LIFE FORCE AND
YOU'LL BE ON COURSE FOR A PEACEFUL HEART
STRAIGHT UP FROM THE START ❦ AS
THESE YEARS ROLL, THERE'S A
GOLDEN COALITION
OF SOULS

YOU'RE MAGNETIC *i'm poetic*
YOU'RE THE REAL DEAL *and i am steel*
YOU'RE WHISKY *i'm kiss me*
YOU'RE EARTHEN *i'm bourbon*
YOU'RE SKEPTIC *and i'm optimistic*
YOU'RE COOL SMART *and i'm ideas start*
YOU'RE EASY *and i'm breezy*
YOU ARE SYNERGY *and i'm energy*

WE are EVERYTHING and ANYTHING
that MAKES the BIRDS sing
and EVERYDAY feel like SPRING
from BOAT RIDES to fun HIGH TIDES
BAIT JUMPING to FIST PUMPING
mountain HIKING to downhill BIKING
that MAKES the BIRDS sing
and EVERYDAY feel like SPRING

our HANDS tell a STORY
hold them up to the SUN'S glory, do
INVENTORY of all the BEAUTY
they bestowed, the HANDS they hold,
from the bumps and falls, they are BOLD
the SOULS they CONSOLED, their
TALES unfold of the weight they pulled,
of the HEARTS so FULL, because
YOUR HANDS are a GIFT, the
spirits they LIFT, the LOVE they convey
the SEASONS they portray, GRATEFUL
for the MIRACLES they play, what is
thought to be exponential decay, is really
a SPIRITUAL BOUQUET of HISTORY
displayed it a remarkable, custom-built way!!

Dimples

I like the way your
dimples peek past your beard
In your direction I steer
So I can hold you near
and look at the sky so clear
See the stars so dear
The ocean waves we hear
Into your eyes I peer
Just 'cuz your dimples appear
makes me happy we are here.

MWH

WORKING SMART IN TUNNEL VISION MODE
SWITCHING BACK TO ENJOY LIFE'S ROAD
PUTTIN' IN THE YEARS ON PUSHING HARD
NOW JUST A 'LIL BIT MORE TIME IN THE BACK YARD
PULLIN' FRUIT OFF THE TREE
THAT'S THE SCENT OF CITRUS, SEE
SIPPIN' SLOW WITH A HAPPY GLOW
THINKIN' OF ALL THE THINGS YOU KNOW
CATCH A BREEZE OF SALT AIR, SPRINKLIN' OF
FRECKLES AND SKIN SO FAIR, MY LOVE
HAS A HALO, DISCIPLINED FROM THE GET-GO
IF I SIT STILL, HE CATCHES MY PHOTO
RESTORES HEARING, MAKES THE SOUND FLOW

i Really Broke My hand and ankle,
My heart sank, HELL, i thought
I was invincible, My body isn't
bendable, I'm dependable (on it)
it's not expendable, but I'm Mendable.
Bones supposed to be straight, to hold
our weight, but ask them to flex
and it's not what they expect,
suffering the effects with respect
of what was thought to be free and easy
turned into pain... Believe Me.
Now i'm battered and thankful not
shattered, i know what matters
My heart goes pitter patters
for My friends and their love chatter.
You got me.
can't you see.
Never ending is My love for thee.

WORLD
OF
plastic

I live in a world of plastic
Where people think in order to be fantastic
You have to do something drastic
Get some work done
Then, you'll be more fun
Wear low-cut dresses
Multi-color your tresses
But, they don't see that aging naturally
Is the real, true beauty
Being strong and lean
And not what's projected in a magazine
Is really the better scene

towards a happier human being

Reason to Be

You sat down by my side. Took me for a trail ride. Watched with me as blue jays soared above the trees, sky as blue as blue can be. Danced on the overlook. I know you like a book. Every day, you make me high. Love you 'til the day I die. Thanks for all you do for me.

You are my reason to be!

WISE WORDS

Usually, I can fix ANYTHING
It comes naturally, I do it casually
I'm not talking about machinery or technology
I'm thinking LIFE'S POTPOURRI
The things that happen ~ they're not on the map
Then, they hit us
Like a ton of bricks
You're upended. SUSPENDED.
In mid-air. In despair.
I say, "WE GOT THIS!" and then we fix it
Sometimes, it's quick
Or, it could take a year. But, I won't disappear!
I'm ALWAYS here. For you, DEAR.

With a plan. An attitude of "we can!"
Some WISE WORDS
From years of dealing with the absurd
Things that life throws at you
You trip the curb, you take my HEALING HERB
And pretty soon, you are feeling superb
But, all it really is... is EXPERIENCE!
From the appearance of life's ingredients
and LEARNING how to run INTERFERENCE
This brings not advice, but...
WISE WORDS!

CAN'T

WHEN SOMEONE WRITES "CAN'T" WITH A CAPITAL C

AND THEN NEXT A GRRRR EMOJI 😬

I GET WHAT IT MEANS, AND THAT'S COOL WITH ME 😎

I PROBABLY "WOULD" IF IT WERE A POSSIBILITY 😍

I'M COMMITTED TO LIFE'S RESPONSIBILITIES 😇

I "SHOULD" PASS ON THIS OPTION PRESENTED 😳

EVEN THOUGH IT "COULD" BE SPLENDID 😏

I'M SLIGHTLY OVER-EXTENDED 😖

BUT, I LOVE THE IDEA YOU PRESENTED 😘

ABOUT

JET WIDICK

Jet Widick is a writer, poet, and mother of two adult sons. A passionate explorer of inner and outer nature, her books are full of warmth, conscience, fortitude and whimsy, and cover a range of topics that reflect the lovely little things that make up our everyday lives—which so often go unnoticed—yet are truly the most important ones of all.

www.jetwidick.com

..

KIMBERLY 國子 TAYLOR-PESTELL

Kimberly Kuniko is the Nikkei American hapa artist and designer behind Lacelit, a paper goods company featuring endearing illustration, sentimental turns of phrase, and clever wordplay. She also loves exploring collage and mixed media art journaling and hosting cozy, virtual Guided Creative Retreats for creatives of all mediums that foster creativity, imagination, and storytelling in all its forms. She resides in what is now known as Monrovia, California, with her husband and their calico tabby cat.

www.lacelit.com

..

kristen alden

Kristen Alden is a writer, visual artist, and graphic designer with a passion for bringing creative ideas to life. After a few years on the West Coast and a couple more in the Upper Peninsula of Michigan, she now spends her time down south developing a vision for the everyday and an organized way of making things more beautiful.

www.kristenalden.com

HEARTFELT.

This is life
Where we all meet
A magnificent world
And so darn sweet